I THINK I CAN
I THINK I CAN

PARTNERS & SPADE

Photos taken on our iPhones August 2008 through July 2009

itbooks

AN IMPRINT OF HARPERCOLLINS PUBLISHERS

*it*books

I THINK I CAN, I THINK I CAN.
Copyright © 2009 by Partners & Spade.

For information, address HarperCollins Publishers,
10 East 53rd Street, New York, NY 10022.

HarperCollins books may be purchased for educational, business, or sales promotional use. For information, please write: Special Markets Department, HarperCollins Publishers, 10 East 53rd Street, New York, NY 10022.

FIRST EDITION

Designed by Partners & Spade

ISBN: 978-0-06-190167-6

09 10 11 12 13 10 9 8 7 6 5 4 3 2 1

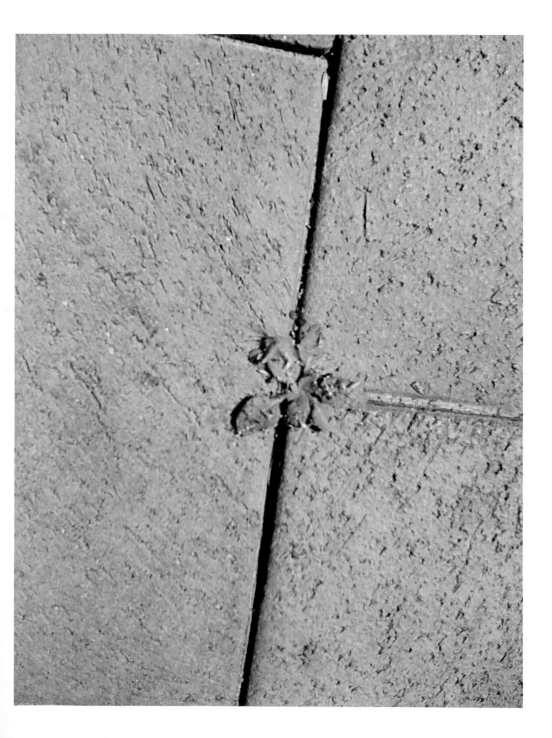

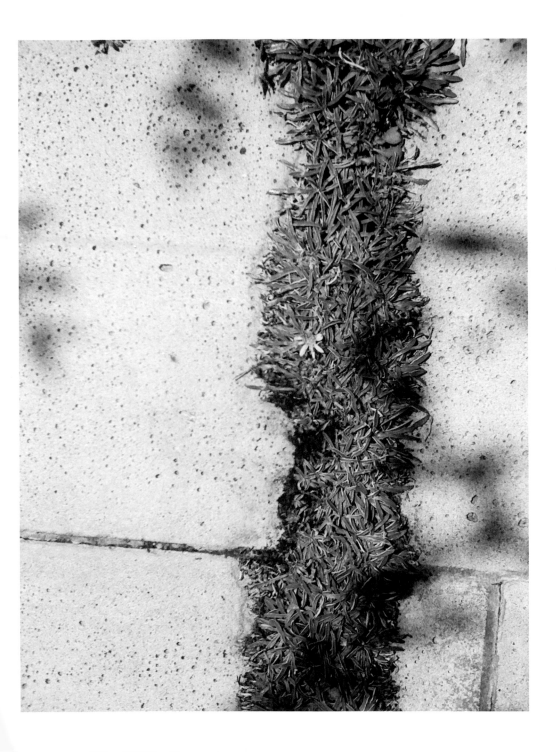

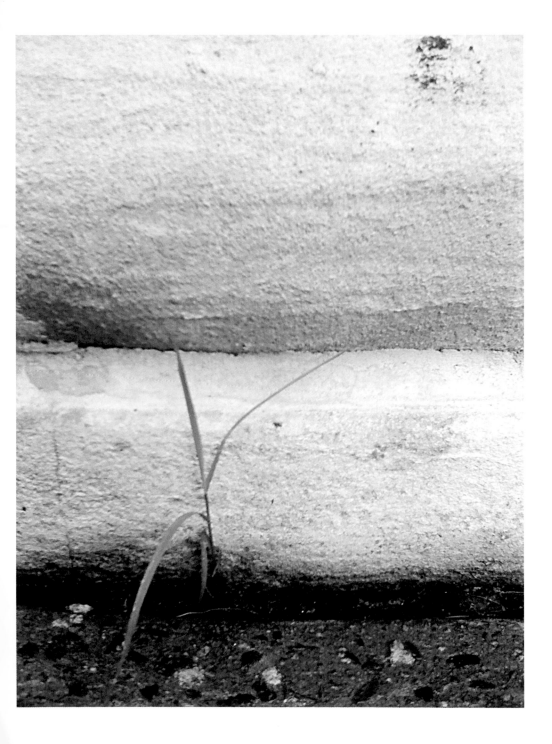

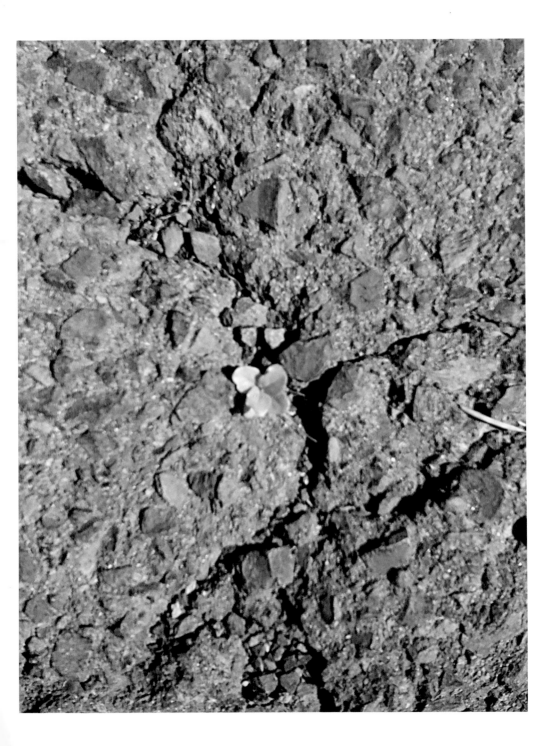

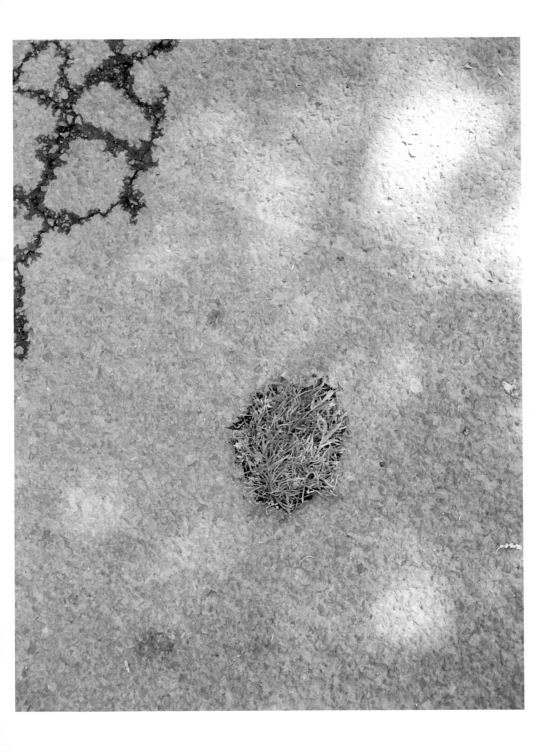

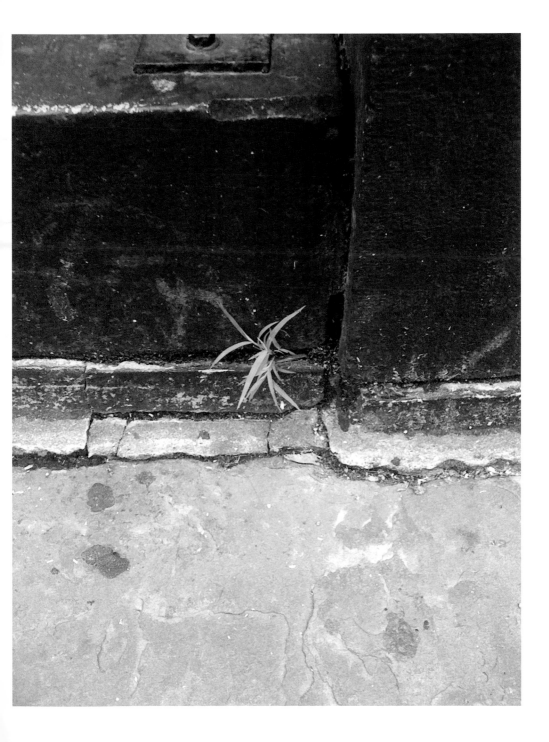

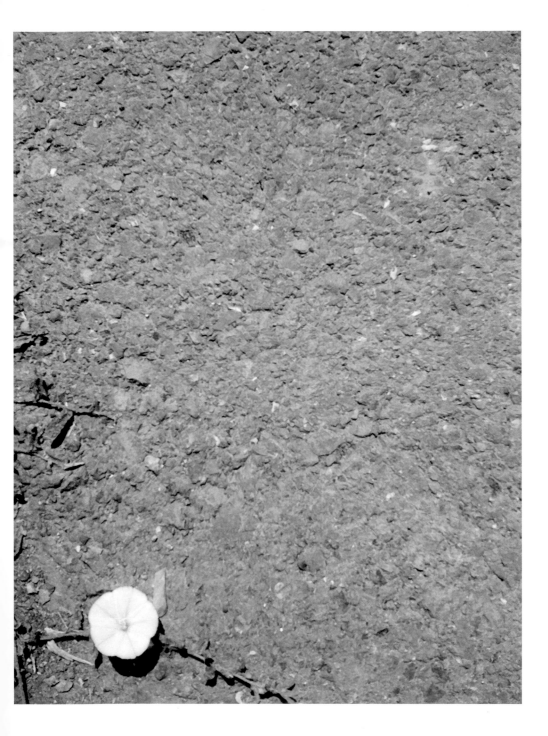

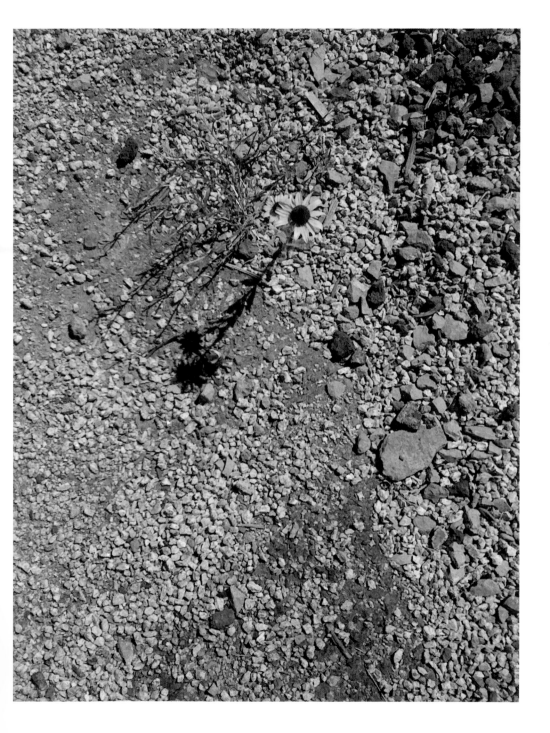

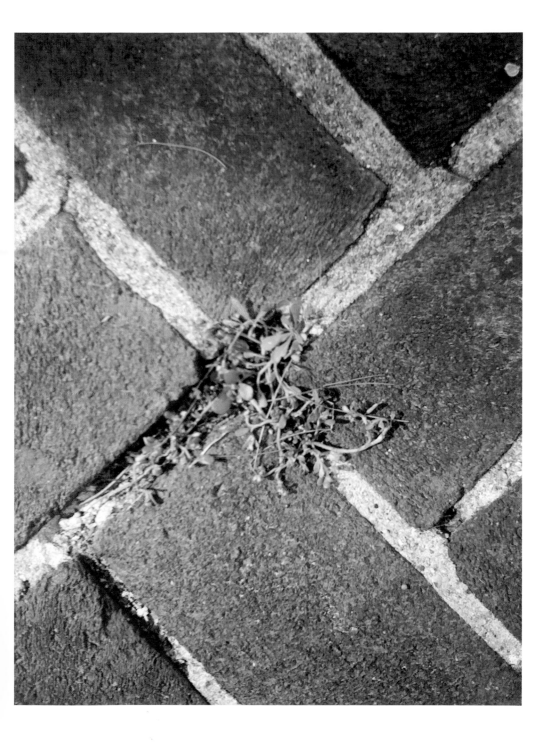

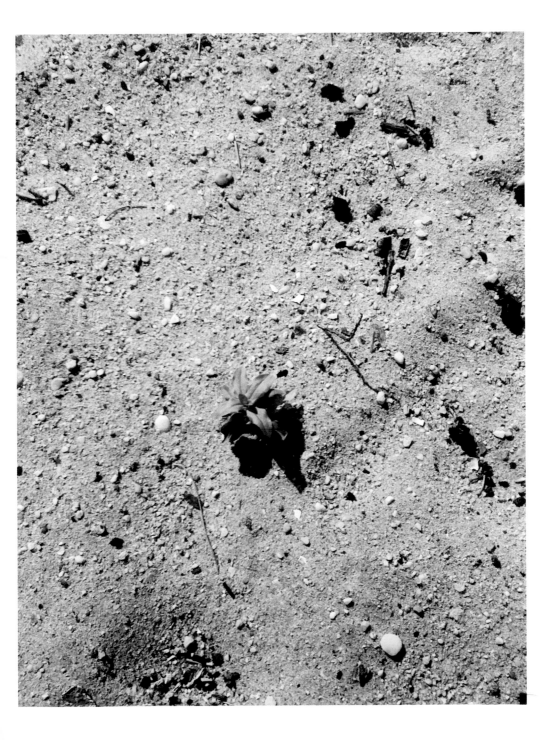

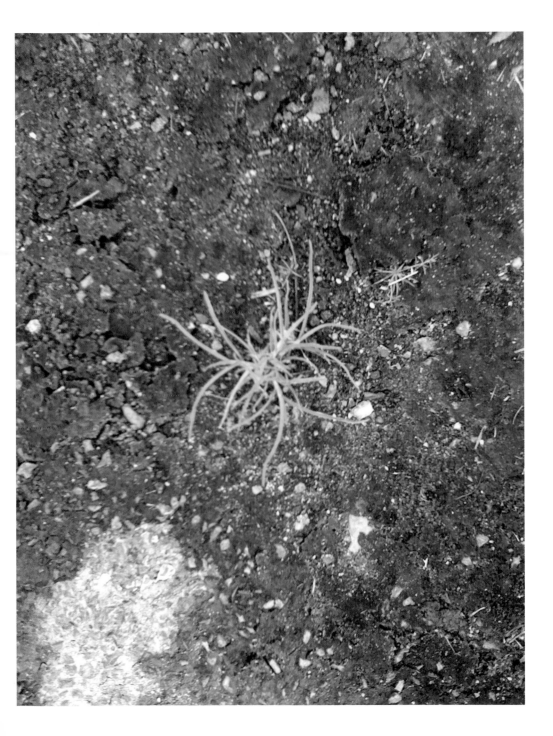

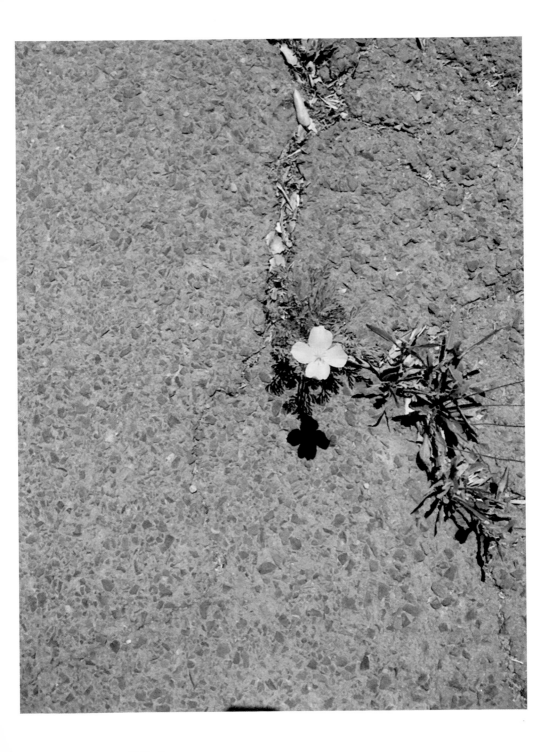

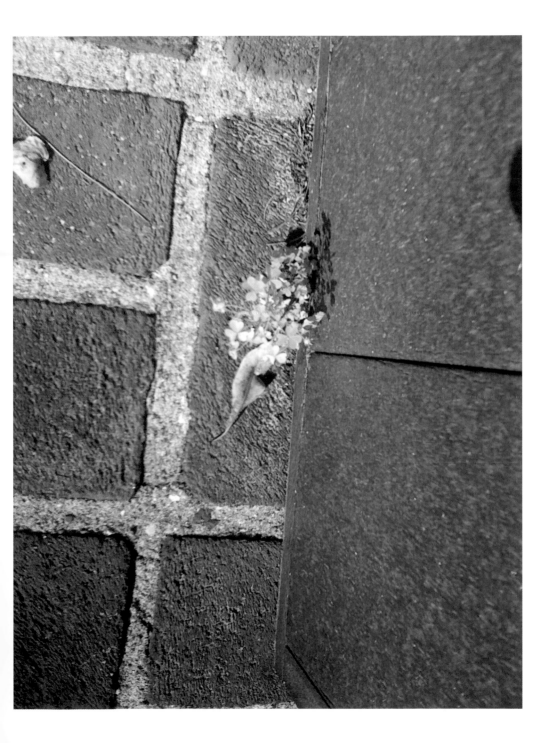

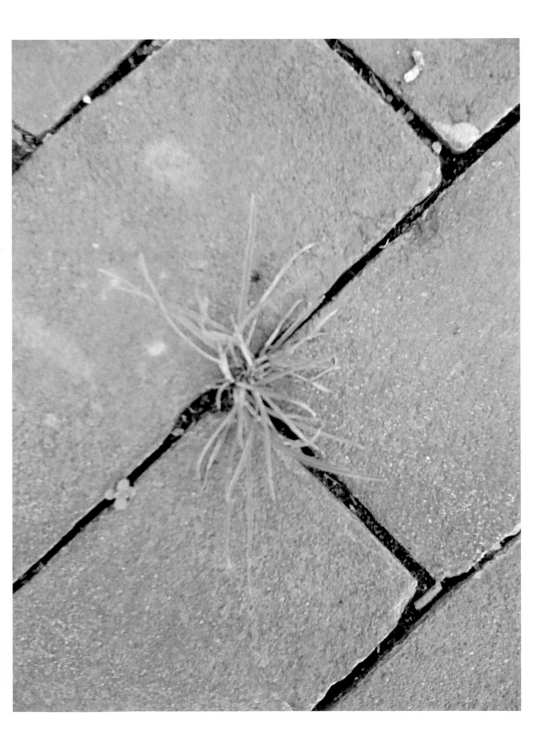

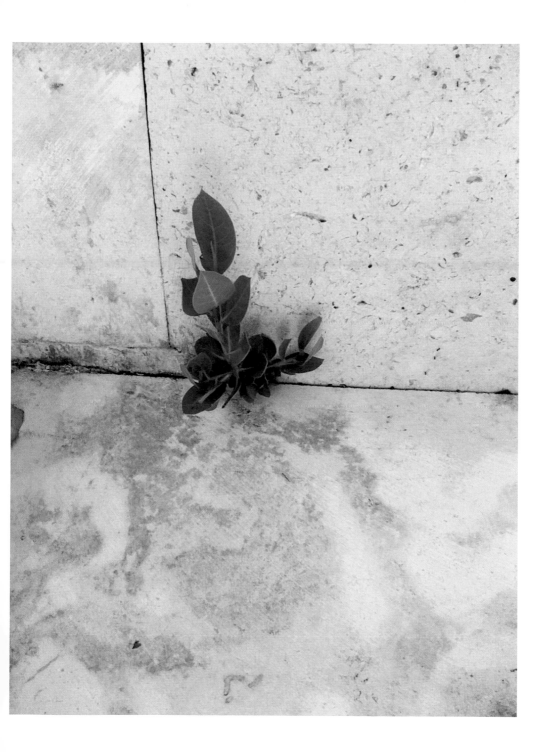

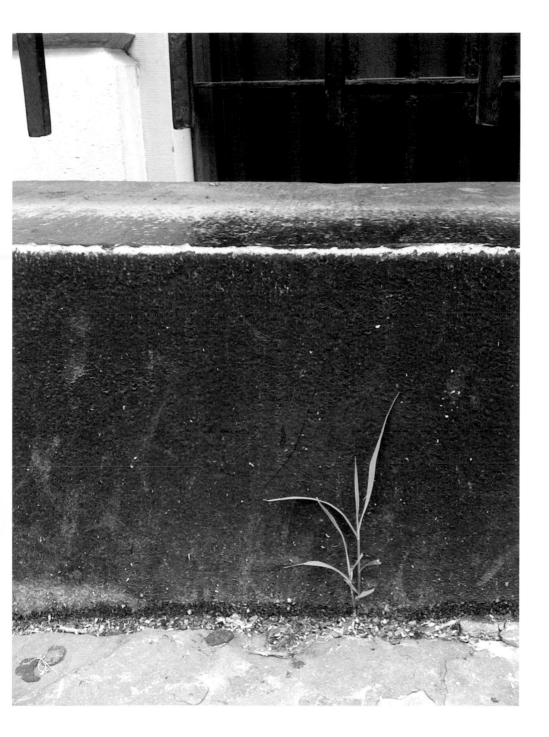

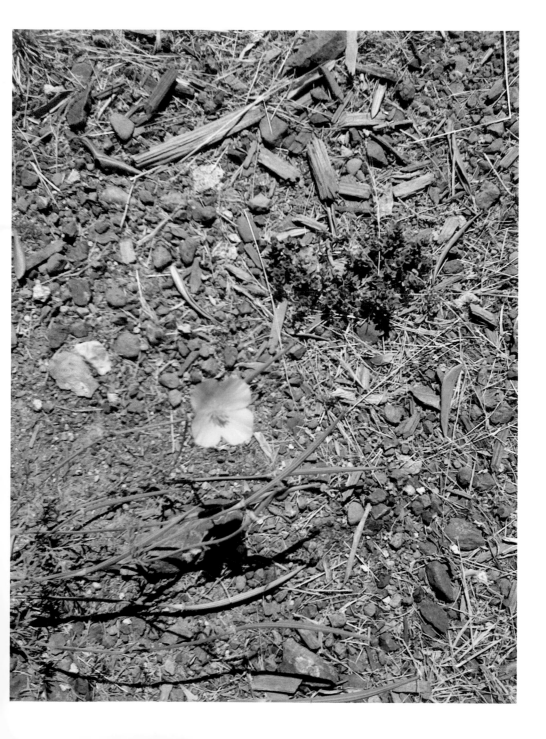

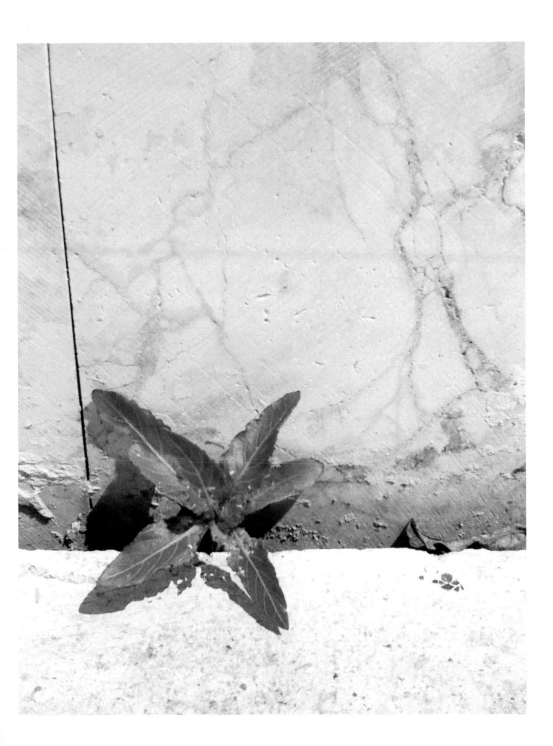

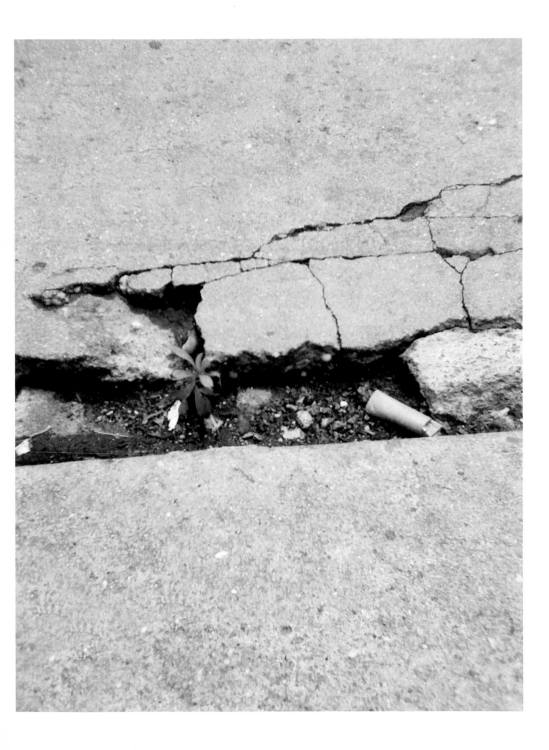

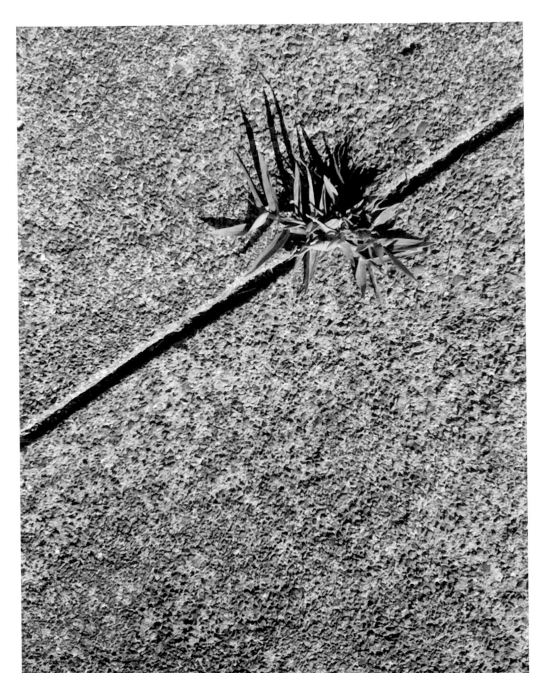

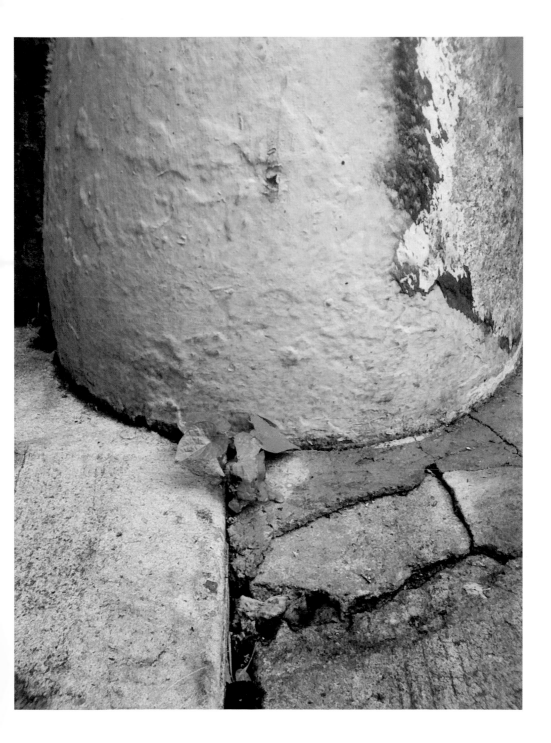

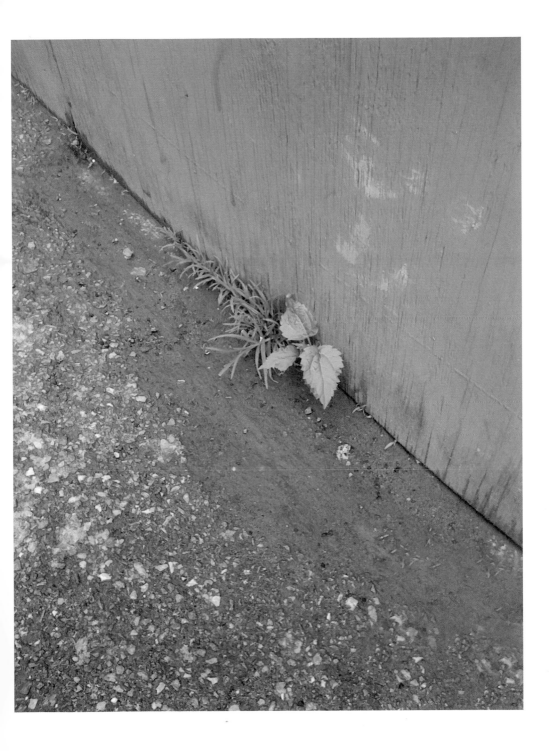

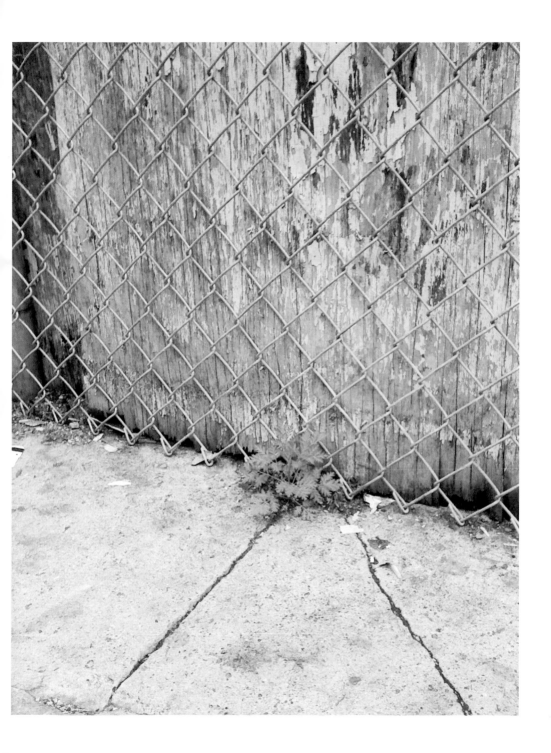

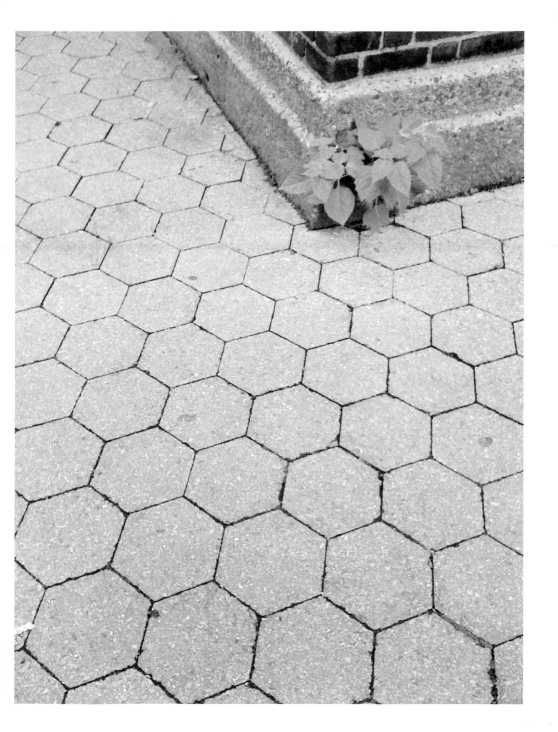

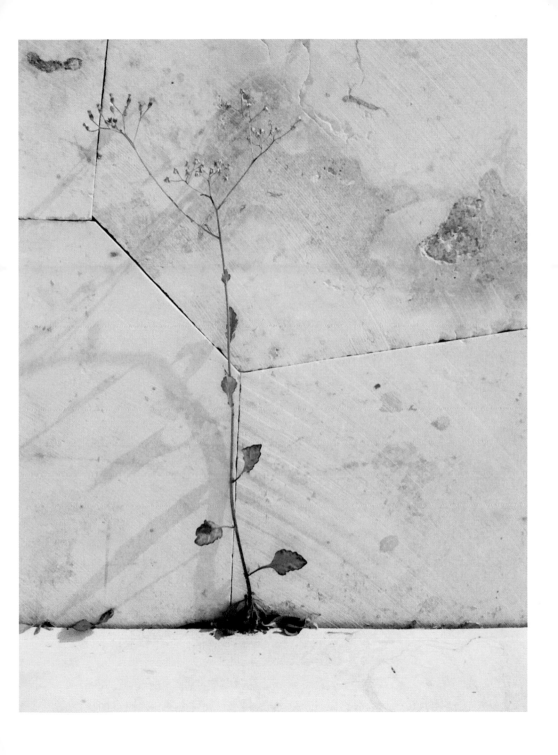

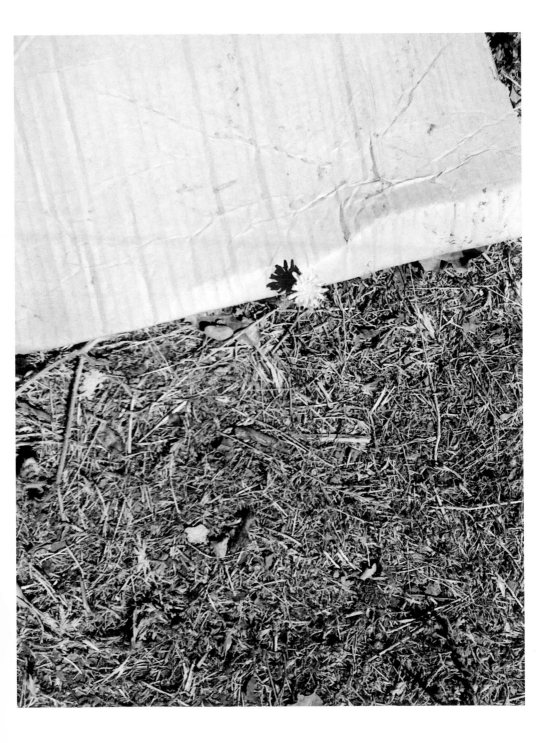

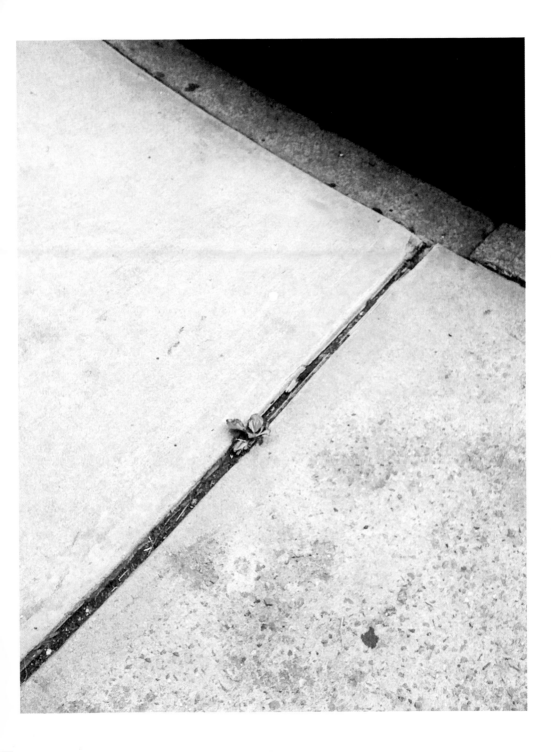

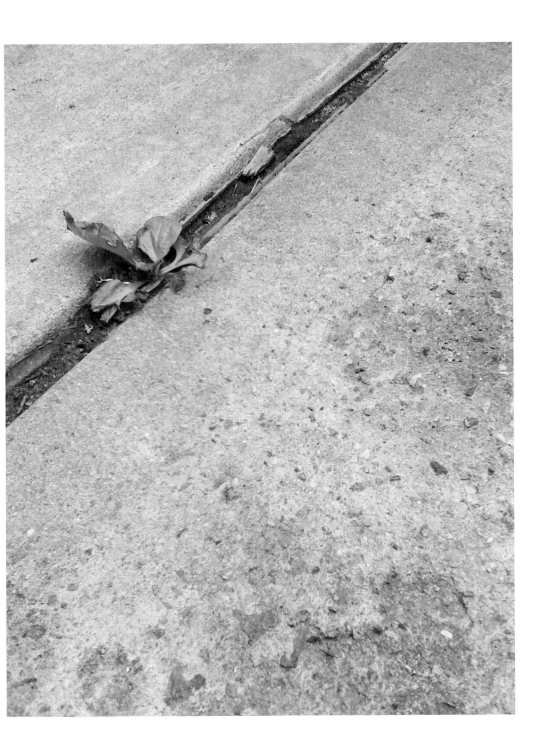

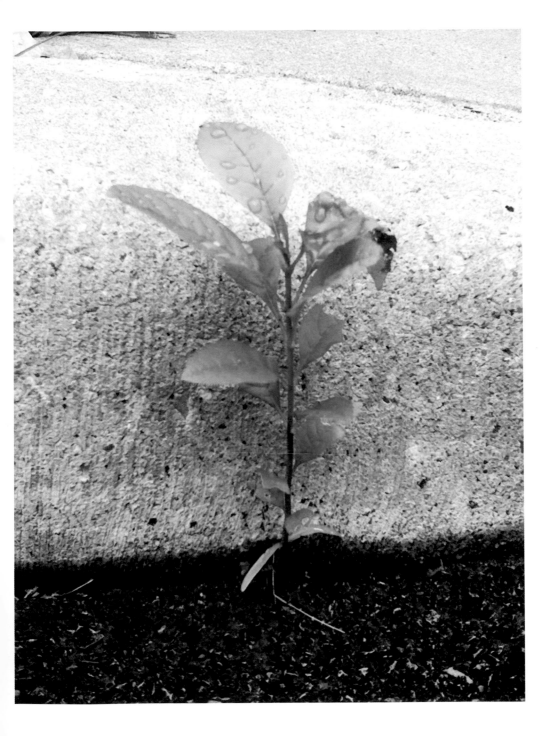

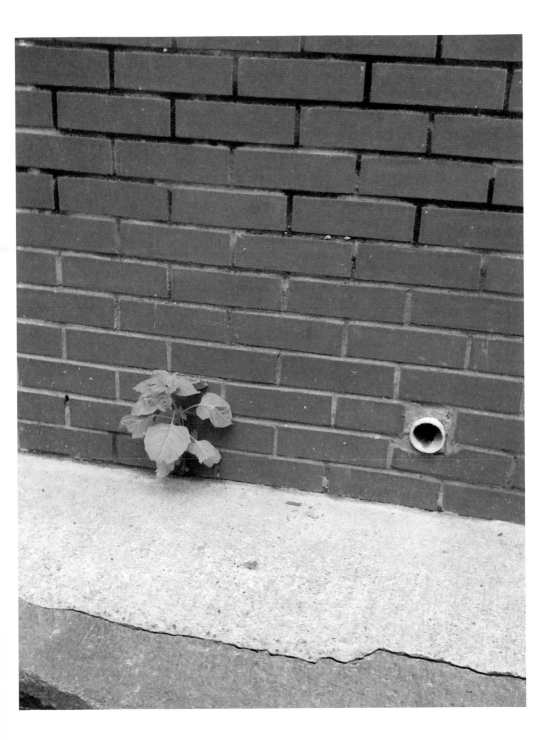

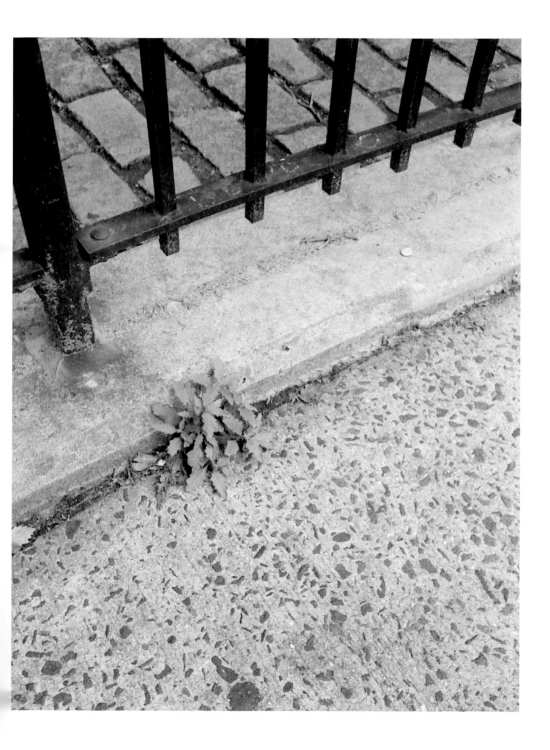

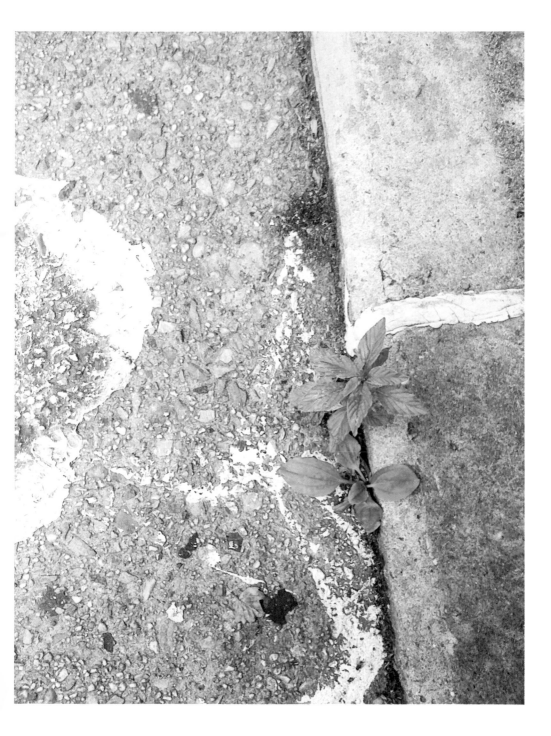

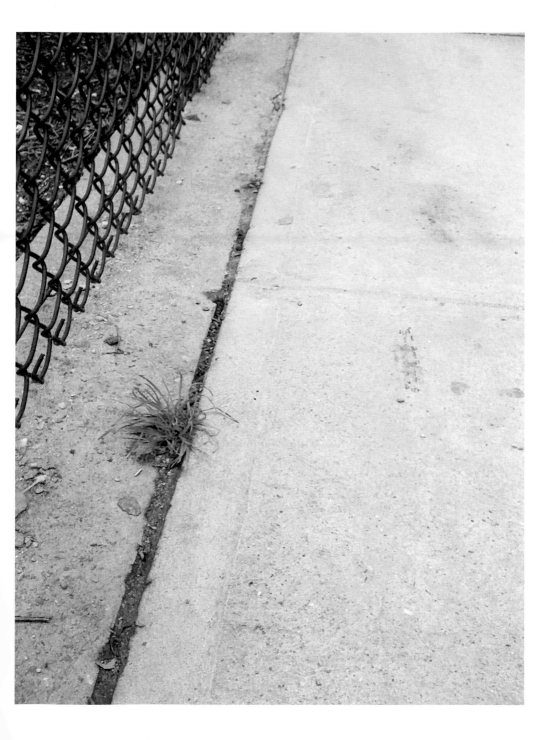

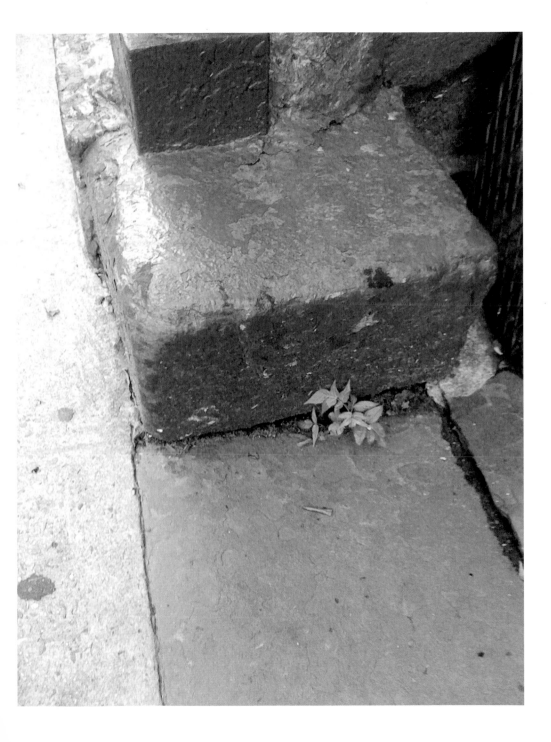

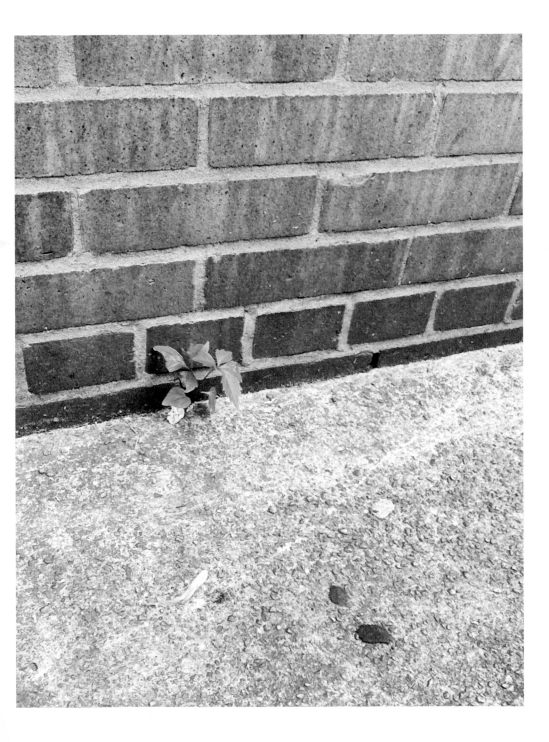

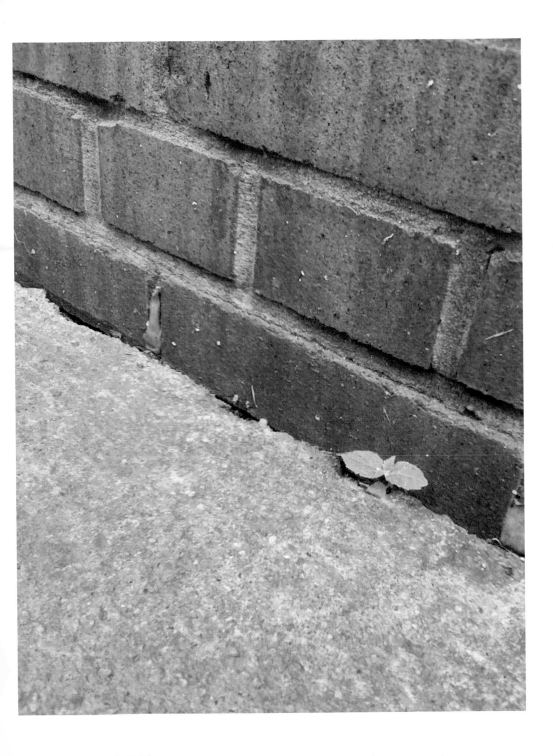

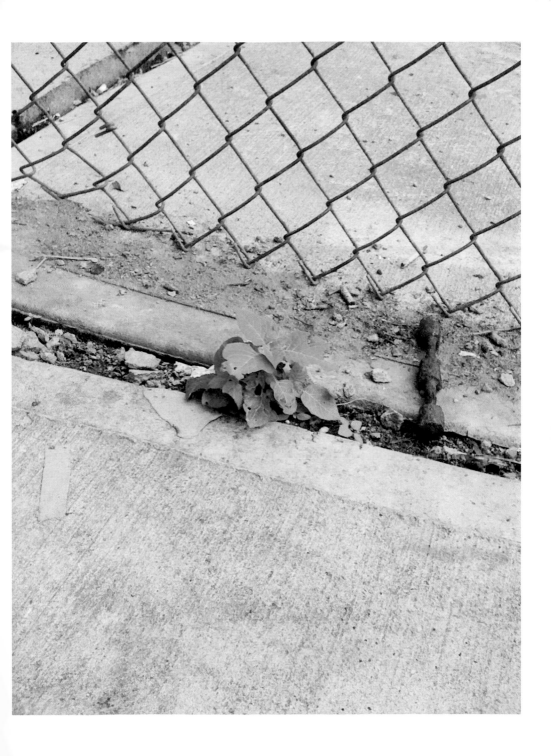

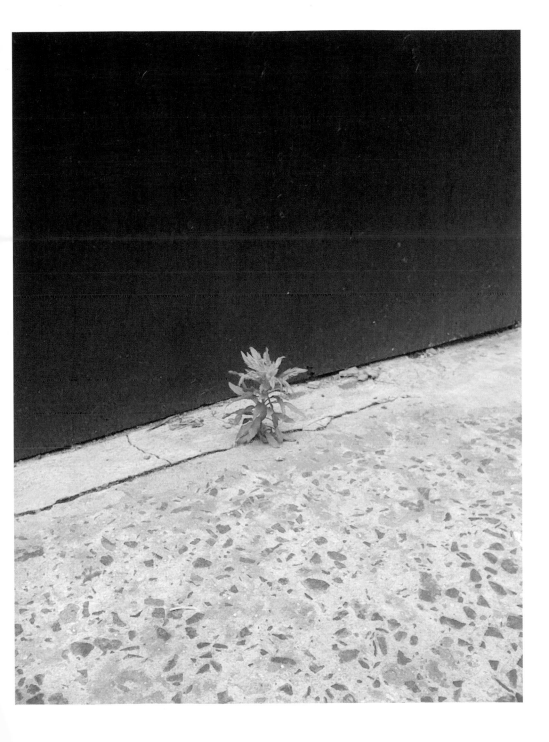

*Partners & Spade is Andy Spade and Anthony Sperduti
collaborating on several creative projects that include film, publishing,
photography and art. They founded the company in 2009.*